DRAW LIKE AN ARTIST

POP ART

Patricia Geis

Princeton Architectural Press · New York

Pop art emerged in
England in the 1950s and arrived
in the United States around 1960.

It was led by a generation of young artists who,
after the Second World War (1939–1945), wanted to
forget the world's problems and reflect in their art
a new way of seeing life that was superficial and fun.

Television had just been invented. People were fascinated
by pop music, Hollywood stars, and the modern way of life
that appeared in magazines and advertisements.
The mass production of new products at low prices meant
everyone could afford to buy them. Pop artists elevated
these desired everyday objects to art.

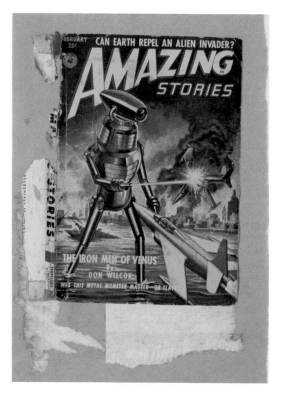

Was This Metal Monster Master—or Slave?, Sir Eduardo Paolozzi, 1952
Printed papers on card, 4¼ x 9¾ in. (36.2 x 24.8 cm)
Tate Liverpool, Liverpool

PAOLOZZI

The Scottish sculptor and artist Eduardo Paolozzi (1924-2005) is considered the father of pop art. When Paolozzi was a young man in the 1950s, many exciting scientific and technological advances were taking place. Televisions became popular, filling homes with advertisements for new products promising to make life easier: washing machines, dryers, vacuum cleaners, dish washers, frozen foods, plastic! Paolozzi thought that such modern technologies, as well as the films, comics, and science fiction they inspired, were works of art. A new art form was born: pop art!

A REFLECTION OF OUR TIME!

Technological advances inspired popular imagination. Science fiction films, novels, and comics flourished. They dealt with themes of outer space, interstellar journeys, robots, and mutations, giving people a glimpse of what the future could look like.

In this work, Paolozzi glued the cover of a science fiction magazine to a piece of cardboard, creating a portrait of the culture in which he lived, and making it a work of art. Paste down something on the next page that reflects our times. And give your work a title!

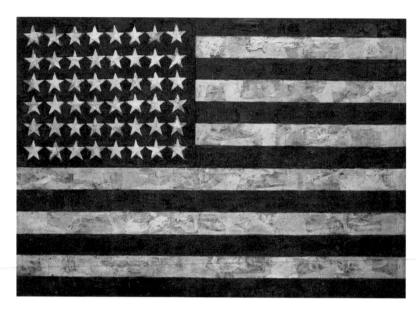

Flag, Jasper Johns, 1954–1955
Encaustic, oil, and collage on fabric mounted on plywood, 42 ¼ x 60 ½ in. (107.3 x 153.8 cm)
Museum of Modern Art, New York

JOHNS

The works of American artist Jasper Johns (1930) feature flags, numbers, letters, and maps—familiar images we've seen so often that we don't tend to pay attention to them. Using broad, colorful brushstrokes, Johns elevates everyday objects to make people see them in a fresh way.

ELEVATE EVERYDAY OBJECTS!

Take a look at this painting of the American flag from 1955: Johns took a familiar object
and painted it in a new way. "But is it art?," people wondered. Paint an ordinary, everyday object
you've never given much thought to (a shopping receipt, a bottle of shampoo, etc.),
and do what Johns did: make it a work of art!

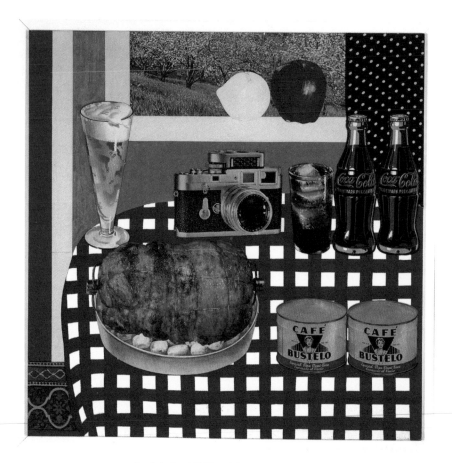

Still Life #12, Tom Wesselmann, 1962
Acrylic and collage of fabric, photogravure, metal, etc. on fiberboard, 48 x 48 in. (122 x 122.1 cm)
Smithsonian American Art Museum, Washington, DC

WESSELMANN

In his still lifes, portraits, and landscapes, American artist Tom Wesselmann (1931–2004) created modern interpretations of traditional subjects. He used simple lines and intense colors to create vibrant and surprising paintings. Wesselmann believed figurative art (which represents things just as they are in reality) to be as moving as abstract art.

A TWENTIETH-CENTURY STILL LIFE

A still life is a painting that depicts objects such as food, flowers, bowls, and water glasses.
In *Still Life #12*, Wesselmann substituted the pheasants, jugs of wine, pumpkins, and ripe fruit that appear in classic still lifes with the foods and objects that modern Americans had in their homes. To do so, he cut out images from magazines and stuck them on hand-painted backgrounds. What would a still life of our time look like?

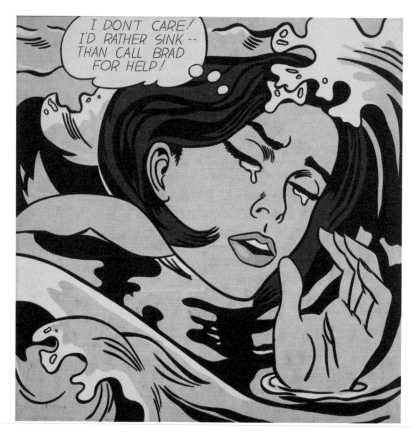

Drowning Girl, Roy Lichtenstein, 1963
Oil and synthetic polymer paint on canvas, 67 ½ x 66 ¾ in. (171.6 x 169.5 cm)
Museum of Modern Art, New York

LICHTENSTEIN

Roy Lichtenstein (1923–1997) was a painter, graphic artist, and sculptor who started pop art in the United States. Lichtenstein's art was inspired by comics. He created versions of comic frames, enlarging them to enormous dimensions, and he imitated the texture of printed paper with dots of color.

WHAT WERE YOU THINKING?!

This picture shows a girl in trouble who thinks, "I don't care! I'd rather sink than call Brad for help!"
Have you ever imagined what a person in a painting is thinking? How would you show what
a person in a painting is thinking? In a text or tweet? Through social media? With emoticons?
Draw your favorite animated characters, and let them express their thoughts!

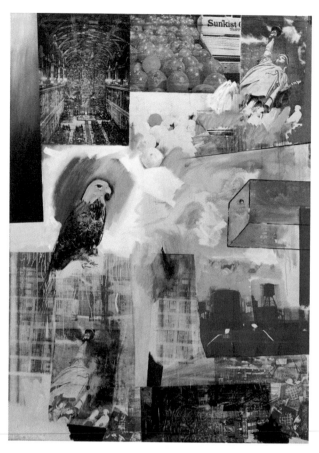

Windward, Robert Rauschenberg, 1963
Oil and silk screen on canvas, 96 x 70⅛ in. (244 x 178 cm)
Beyeler Foundation, Basel

RAUSCHENBERG

Robert Rauschenberg (1925–2008) was an American painter and artist who lived during the shift from abstract expressionism to pop art. Abstract expressionism was a movement characterized by expressing emotion and feeling through vigorous brushstrokes.

EXPRESS YOURSELF!

Rauschenberg cut images from magazines and newspapers and combined them with drawings and paintings. He wanted to juxtapose the prefabricated and the superficial with the creative and the personal. Cut out images from newspapers and magazines, glue them to the following page, and express with broad brushstrokes how they make you feel.

12

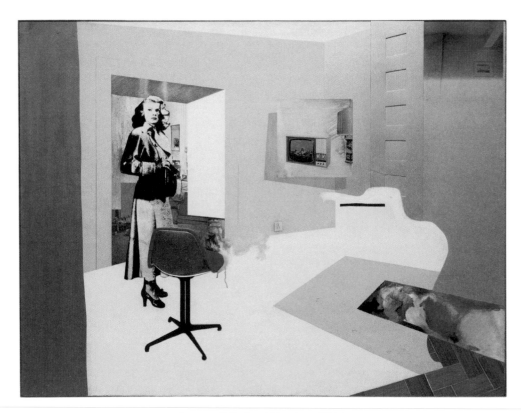

Interior II, Richard Hamilton, 1964
Oil paint, cellulose paint, and printed paper on board, 48 x 63 ⅞ in. (121.9 x 162.2 cm)
Tate Gallery, London

HAMILTON

Richard Hamilton (1922–2011) was a pioneer of British pop art. His provocative and entertaining paintings combined the classic and the modern to portray consumer society, which—through advertising—had begun to make us think we needed to buy more and more goods, convincing us to care only about superficial things instead of focusing on what is really important.

WHERE IS PATRICIA KNIGHT?

Hamilton cut out silhouettes of the actress Patricia Knight from a photo still of an old film and incorporated them, with a backdrop of 1970s-style décor, into collages. In *Interior II*, he included an image of the actress looking away from a television screen that shows the assassination of President Kennedy. Hamilton wanted to criticize how we're so used to seeing tragedies on television that we're no longer affected by their gravity.
Make your own version of this scene, placing Patricia Knight in your own imagined background.

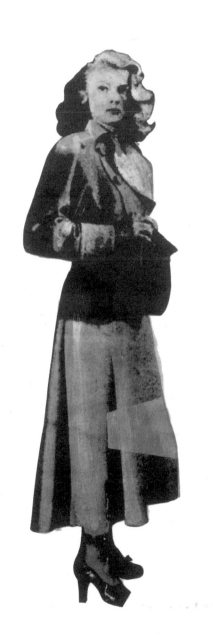

Spaghetti, James Rosenquist, 1965
Oil on canvas, 30 x 30 in. (76.2 x 76.2 cm)
Private collection

ROSENQUIST

The American artist James Rosenquist (1933) started his career painting advertising murals. From the beginning he was fascinated by making larger-than-life reproductions of everyday objects, and he became interested in the representation of texture, color, line, and form.

LARGER THAN LIFE!

The artist was once asked why he portrayed spaghetti so frequently, to which he replied, "Two reasons: I like the way it looks, and I like the way it tastes." Can you imagine your favorite food depicted at such an astonishingly large scale, the way Rosenquist did in this work? Paint your favorite food so that it's just as appetizing!

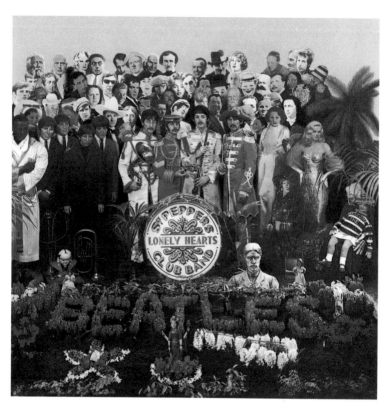

Sgt. Pepper's Lonely Hearts Club Band album cover, Peter Blake, 1957
Collage, enamel, wood, 36 x 24 in. (91.4 x 61 cm)
Tate Modern, London

BLAKE

Peter Blake (1932) is one of the founders of British pop art. He wanted young people who were thrilled by the Beatles and the Rolling Stones to be as thrilled by his paintings. In his work, he mixed cut-outs from newspapers, photographs of celebrities, logos, and brightly colored geometric designs to create exciting works of art.

DESIGN YOUR OWN ALBUM COVER!

Blake designed the cover of this album by the Beatles, the most famous group in pop music.
Album covers, which until that moment had been mere coverings, became a means of artistic expression
and helped create an image of the musicians and their music. Here the Beatles pose dressed up as
an imaginary band in front of an audience made up of famous celebrities—from actors like Marilyn Monroe
and Charlie Chaplin to scientists like Albert Einstein and writers like Oscar Wilde and Edgar Allan Poe.
If you were in a band, how would you design the cover of your album?

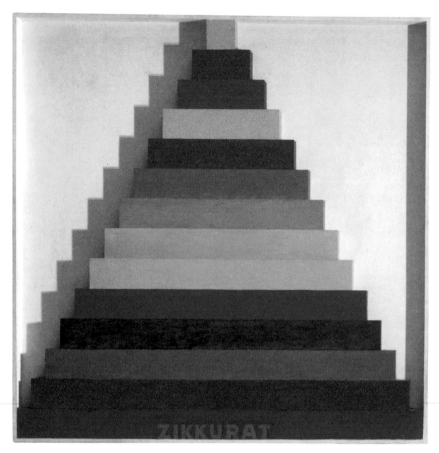

Zikkurat 2, Joe Tilson, 1967
Oil and acrylic on wood, 84 5/8 x 84 5/8 x 5 1/2 in. (215 x 215 x 14 cm)
Galleria Nazionale d'Arte Moderna e Contemporanea, Rome

TILSON

Joe Tilson (1928) is a British painter, sculptor, and engraver. Before devoting himself to art, Tilson was a carpenter. With his woodworking skills he creates abstract bas-reliefs using colors and shapes that echo children's construction toys.

ARTFUL CONSTRUCTIONS!

Have you ever built an amazing structure and then had to destroy it to put away the pieces?
Tilson immortalized these constructions, framing them as the works of art that they are.
Create your own artful construction using the figures you'll find in the Extra Materials section
at the end of the book.

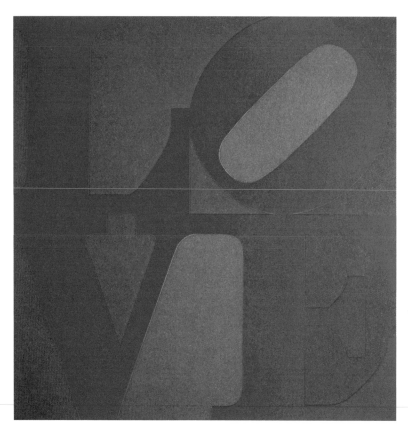

Love, Robert Indiana, 1968
Oil on canvas, 71 7/8 x 71 7/8 in. (182.5 x 182.5 cm)
Indianapolis Museum of Art, James E. Roberts Fund

INDIANA

The American artist Robert Indiana (1928) defined himself as a painter of signs. Symbols, numbers, and letters indicate where we should go, where things are located, when we can cross the street, what apartment we live in, what film is being projected in the cinema and at what time. Indiana thought these elements were the simplest, most orderly, and most effective way of communicating. That's why he made them the subjects of his work.

WORD PORTRAITS

Have you ever seen a portrait of a word? This painting is a one-word poem. The word "love" is a noun, a verb, and an imperative. With a vibrant contrast of colors, the artist shows that love is the force that moves us. Make your own colorful composition with the letters that you'll find in the Extra Materials section, or make a portrait of one of your favorite words.

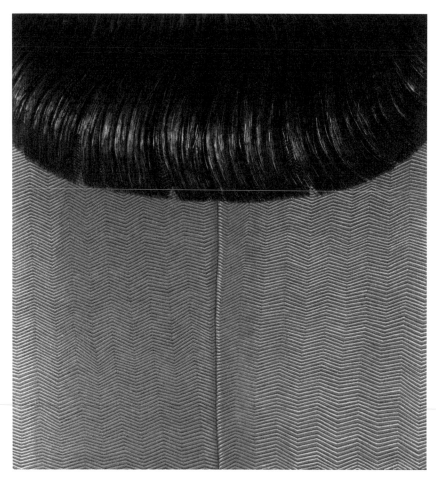

Red Hair on Blue Dress, Domenico Gnoli, 1969
Oil on canvas, 70 ½ x 63 in. (179 x 60 cm)
Private Collection

GNOLI

The Italian painter Domenico Gnoli (1933–1970) portrayed everyday objects such as chairs and beds. He painted the small details of trivial things—the heel of a foot, the neck of a shirt, the knot of a tie, a button—on such a large scale and in such precise detail that they became abstract works!

IMAGINE THE REST!

In showing us only a piece of an object or scene, Gnoli's works leave us intrigued.
What would the rest be like? Draw how you think the complete image would appear.

24

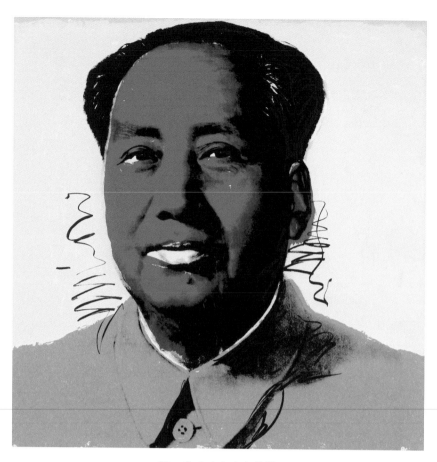

Mao, Andy Warhol, 1972
Synthetic polymer paint and silkscreen on canvas, 36 x 36 in. (91.4 x 91.4 cm)
Private collection

WARHOL

Andy Warhol (1928–1987) was the leader of the pop art movement in the United States. He was also one of the most famous and influential artists of the second half of the twentieth century. His best-known works represent symbols of mid-century modern American society. The subjects of his paintings were famous people and products found on supermarket shelves.

MAKE A PORTRAIT OF A FAMOUS PERSON!

Warhol painted the personalities of the moment in which he lived: film stars, singers, designers, writers, aristocrats, businessmen, politicians, heads of state. To be the subject of a Warhol portrait was an honor. The artist made different colorful versions of original black-and-white images, creating vibrant new compositions. What famous person from today would make a great pop portrait? Paste a black and white photocopy of this person's face onto the page, and then color it!

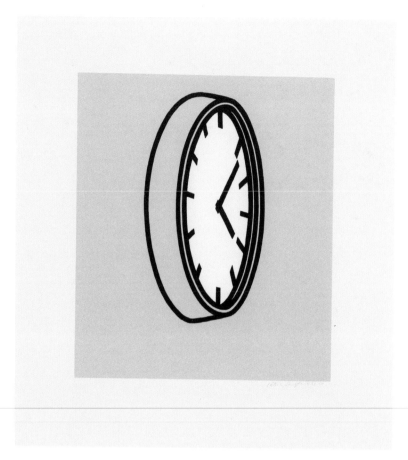

Crying to the walls: My God! My God! Will she relent?, Patrick Caulfield, 1973
Screenprint on paper, 24 x 22 in. (61 x 56 cm)
Tate Gallery, London

CAULFIELD

Patrick Caulfield (1936–2005) was a British artist known for representing simple everyday objects in bold, black outlines and solid colors. Despite its simplicity, his artwork evokes mystery, prompting the viewer to interpret its meaning.

PROVOKE MYSTERY!

Take a close look at this image: a simple, modern wall clock. Then read the title of the work.
Look at the clock again. What does the title refer to? Is it late and someone didn't arrive?
Is someone about to do something dangerous? Do you now see this work in another light?
Draw a simple image of your own, and give it a mysterious title.

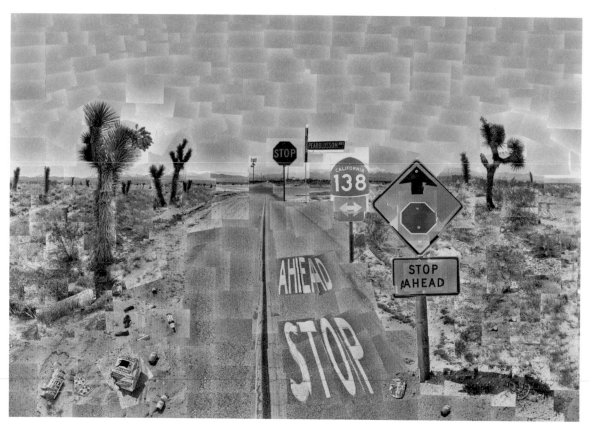

Pearblossom Highway, 11–18th April 1986, #2, David Hockney, 1986
Photographic collage, 71½ x 107 in. (181.6 x 271.8 cm)
The J. Paul Getty Museum, Los Angeles

HOCKNEY

British artist David Hockney (1937) creates portraits and landscapes of luminous and vibrant atmospheres, such as pools and highways. To create such luminosity, Hockney uses paint or collages of images taken with his Polaroid camera, printers, faxes, and even his iPad. The artist calls his collages "drawing with the camera."

DRAW WITH A CAMERA!

To create this collage, Hockney took nearly eight hundred photographs of the same place from different points of view. None of the photos is taken from the center of the highway. If you look closely, some are taken from above, while others are shot from below or from the right or the left. Many are close-ups, which is why you can see the smallest details of the landscape, no matter how far away it is. Make a collage with the photographs (found in the Extra Materials section) to recreate the sensation that you're on the highway.

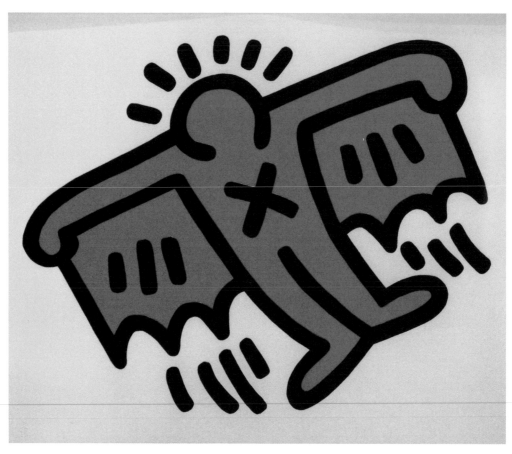

Icons 1, Keith Haring, 1990
Silkscreen with embossing, 21 x 25 in. (53.3 x 63.5 cm)
Estate of Keith Haring, New York

HARING

The artist Keith Haring (1958–1990) brought pop art to the streets of New York in the 1980s. He started as a street artist, creating his own universe of icons: people, babies, superheroes, dogs, angels, pyramids, and UFOs, which he repeated again and again in the subways and on the city's streets. Later, Haring transposed his street art to paper and canvas but never lost the power, spontaneity, simplicity, and speed of his graffiti.

SPEED!

Street artists need to know what they want to make before they start because they only have a single opportunity to create it and must work very quickly.

Do you have your clock ready? You have thirty seconds to create your own icon! Go!

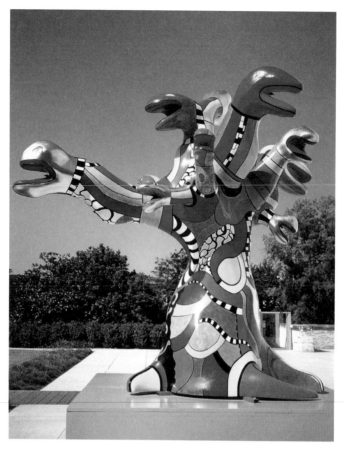

Serpent Tree, Niki de Saint Phalle, 1992
Polyester and polyurethane paint, 124 x 140 ⅛ x 89 ¾ in. (315 x 356 x 228 cm)
Musée des Beaux-Arts, Angers

SAINT PHALLE

The French artist Niki de Saint Phalle (1930–2002) was a painter, sculptor, and filmmaker. She was also a well-known personality who, like Warhol, made use of the media to promote her daring and dynamic art.

TAMING WITH COLOR!

In this sculpture, Niki de Saint Phalle "tames" what frightens her (snakes) and converts her foes into friends by transforming them into the branches of a tree and filling them with color and joy.
Turn something you fear into something friendly and happy using color.

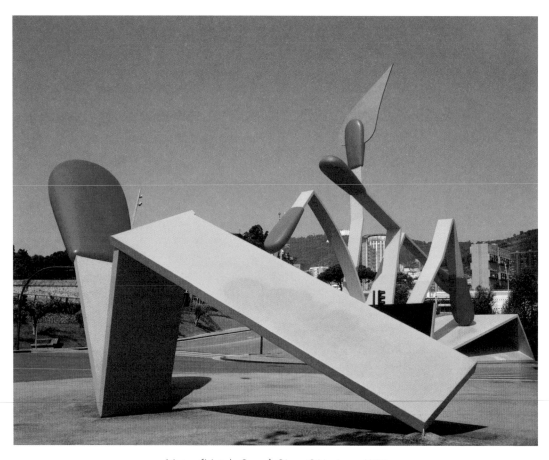

Mistos (Match Cover), Claes Oldenburg, 1992
Steel, aluminum, fiber-reinforced plastic; painted with polyurethane enamel, 81 ⁵/₈ x 39 ³/₄ x 52 in. (207.3 x 101 x 132 cm)
Parc de la Vall d'Hebron, Barcelona

OLDENBURG

Claes Oldenburg (1929) is a Swedish artist who brought pop art to sculpture. By recreating everyday objects on a gigantic scale, these objects cease to be normal and become something surprising. If you walk beside one of Oldenburg's sculptures, you might ask, "Is it a giant sculpture, or have I shrunk?"

POWER TO THE INSIGNIFICANT!

Oldenburg converts a matchbook into a sculpture that's over sixty feet tall.

Red and yellow matches are bent and scattered about, and one of them is lit with a blue flame.

Cut out the matches (found in the Extra Materials section) to make your own version of this sculpture.

36

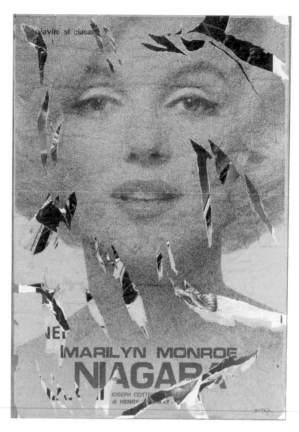

Marilyn Languid 1, Mimmo Rotella, 1998
Screenprint and décollage on cardboard, 39 3/8 x 27 1/2 in. (100 x 70 cm)
Private collection

ROTELLA

The Italian artist and poet Mimmo Rotella (1918–2006) worked not in collage but in décollage. Unlike collage, which creates an image through fragments of other existing images, décollage is created by cutting, scratching, or eliminating parts of an original reproduction. Rotella created her works by tearing layers of film posters glued to canvas, to imitate the look of billboards.

DÉCOLLAGE!

Rotella's work shows how short a time popularity lasts in today's consumer society.

Something that is important one day is forgotten the next, when it is replaced by another novelty.

Make your own décollage! Paste one or two images on top of each other on a page.

Once the glue is dry, (carefully!) tear fragments from one layer to expose the second.

EXTRA
MATERIAL

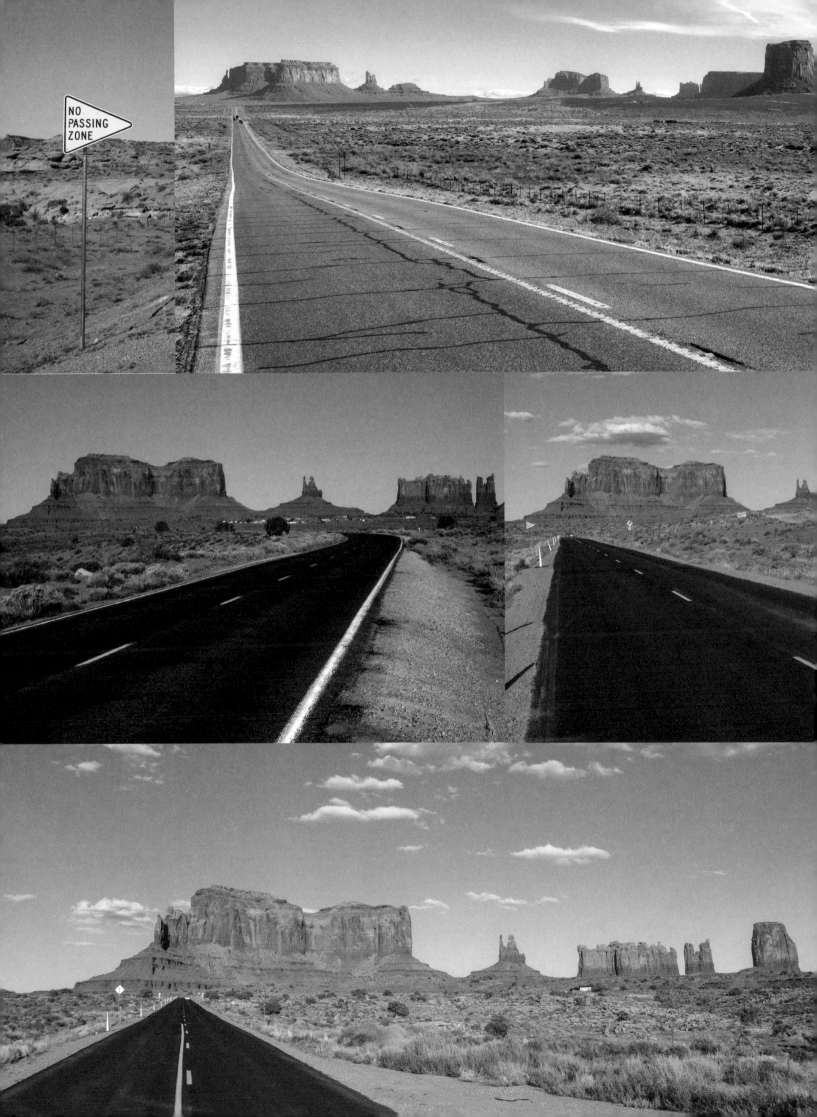